How to Draw
Kawaii
Girls & Boys

In Simple Steps

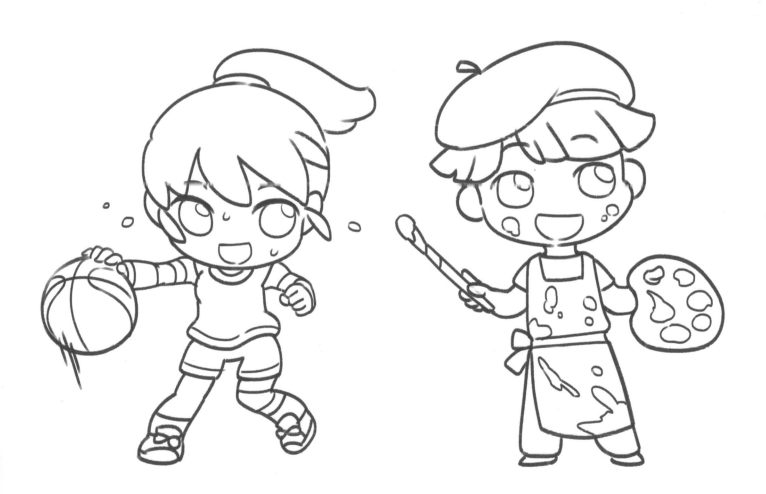

First published in Great Britain 2021

Search Press Limited
Wellwood, North Farm Road,
Tunbridge Wells, Kent TN2 3DR

Reprinted 2021, 2022

ISBN: 978-1-78221-919-4

You are invited to visit the author's website:
www.liyishan.com

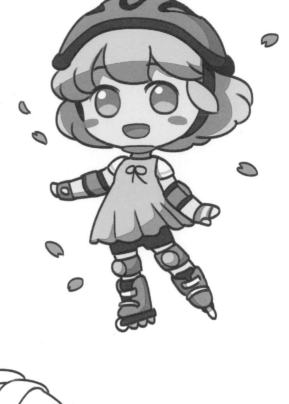

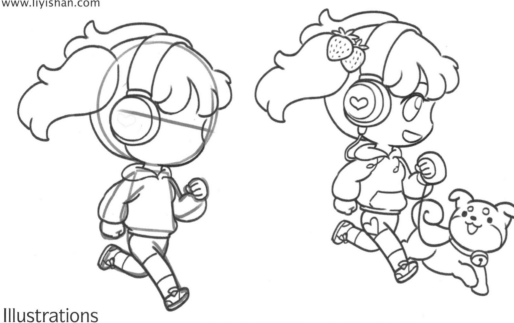

Illustrations

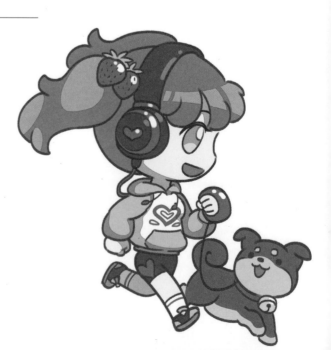

How to Draw
Kawaii
Girls & Boys

In Simple Steps

Yishan Li

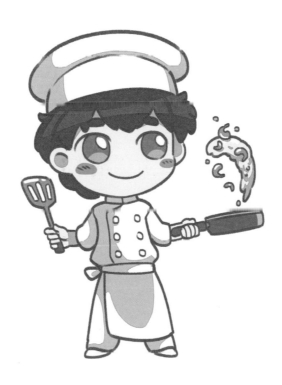

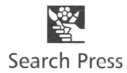

Search Press

Introduction

If you have watched anime or read Manga books, you probably already know the word 'kawaii'. In Japanese, kawaii means cute, adorable or loveable, and it is a massive part of Japanese culture.

Kawaii characters are distinctly recognizable with their massive, baby-like heads and eyes. They are the mini version of normal-sized anime characters. The good news is that they are probably the easiest starting point if you want to learn how to draw anime characters. So if you love the cuteness of kawaii girls and boys, with a little help from this simple-to-follow book, you can learn to draw them yourself!

In this book, there are twenty-eight finished images of Kawaii boys and girls. Each of them has eight steps to guide you through the whole drawing process. They all start with very simple shapes, then gradually build up more shapes and details. I use different colours to indicate new strokes added in each new step. The first shape is always in blue, then new shapes added on will be in pink; after that, black lines are used to actually draw the image itself, then the final image is fully coloured to show you the completed picture.

When you practise, all you need is paper, a pencil and an eraser. I prefer normal copying paper to special art paper because it's cheaper and easy to draw on. You can choose any soft graphite pencil, preferably 2B. The eraser can just be the one you normally use at home or school.

When drawing the initial shapes, start with very light strokes, then when you are adding more details, you can use slightly more solid lines. This way you can see your final image clearly rather than losing it among all the messy lines.

Once you are more confident with your black and white pencil drawings, you can add ink and colours. You need an ink pen and colouring materials. The ink pen can be any black waterproof gel pen. Try it first on a spare piece of paper to make sure it doesn't smudge.

When you have inked in the drawing, you can clear away all the pencil lines with the eraser. For colouring pens, I prefer water-based dye ink pens, but if you would rather use something easy to find at home, you can also use watercolour or ordinary coloured pencils.

The most important thing I hope you will learn from this book is to be creative. With a little twist here and there on these existing characters, you can create a brand new character. In fact you can easily draw anyone you like as a kawaii character if you just let the creativity take you!

Happy Drawing!

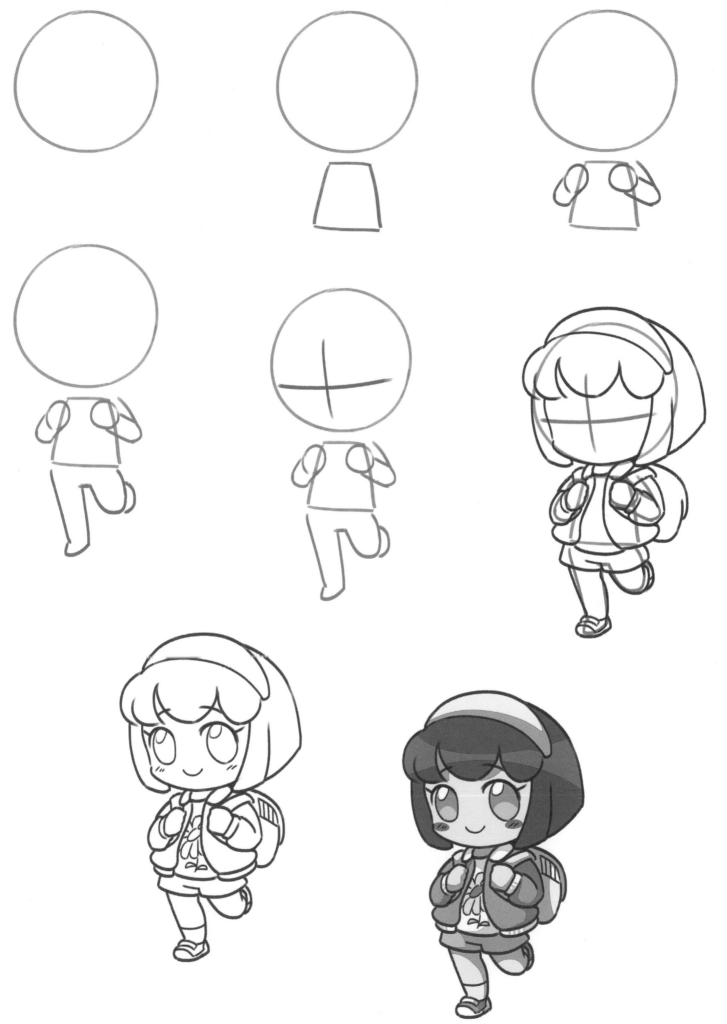

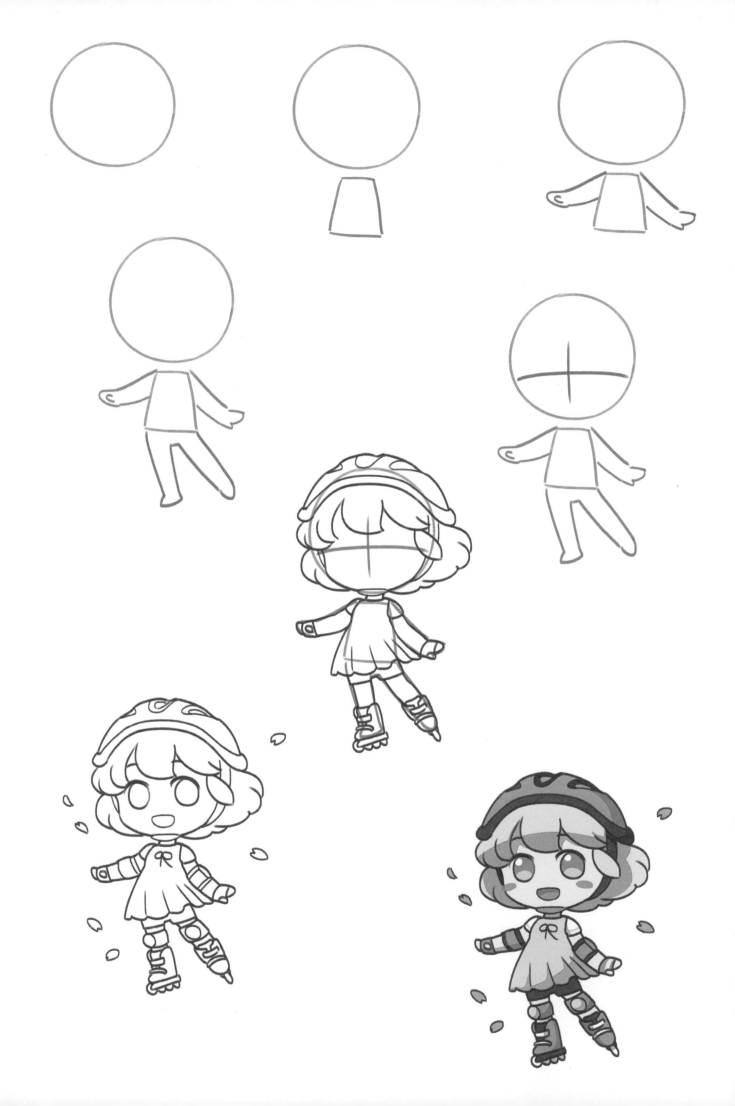

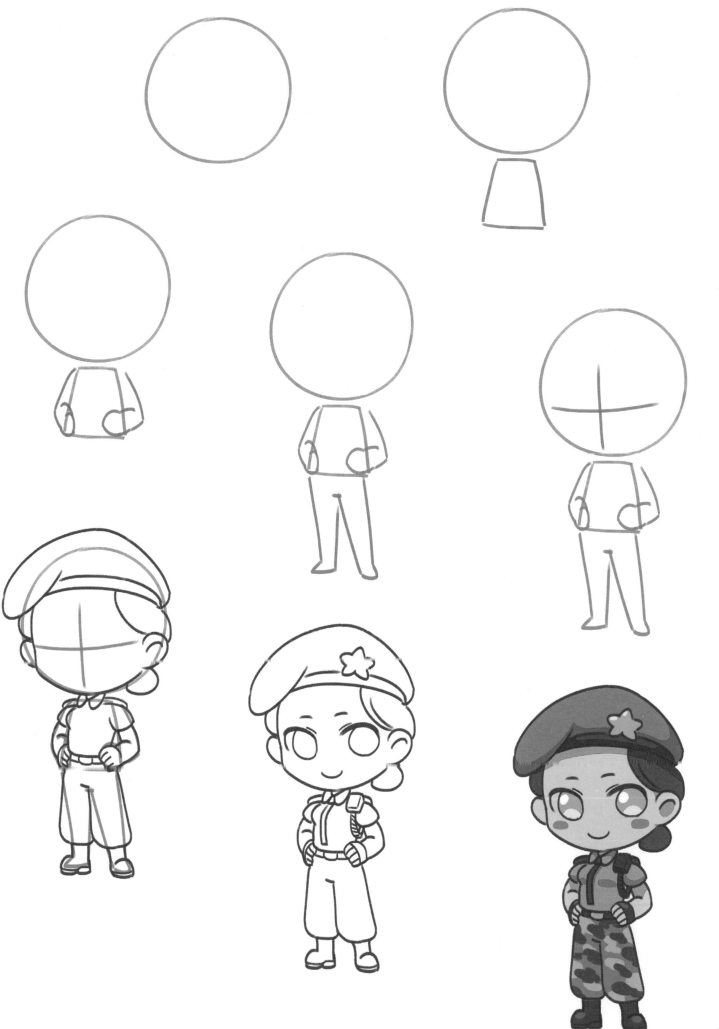

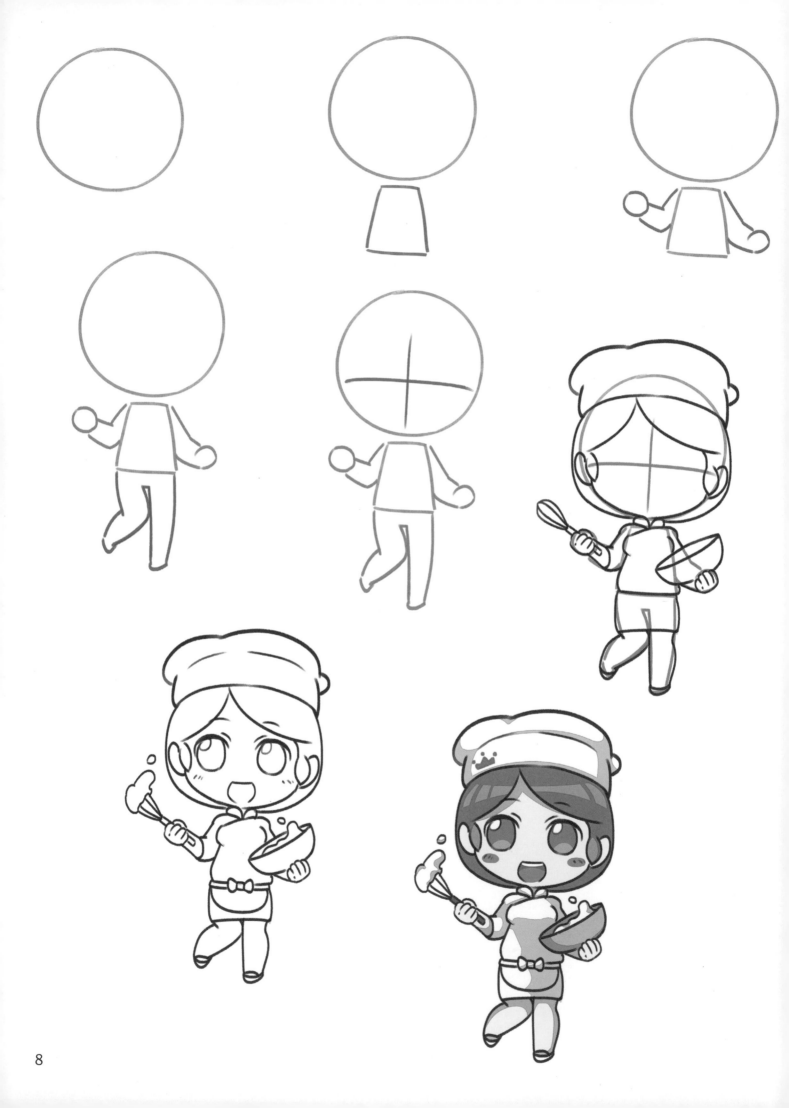

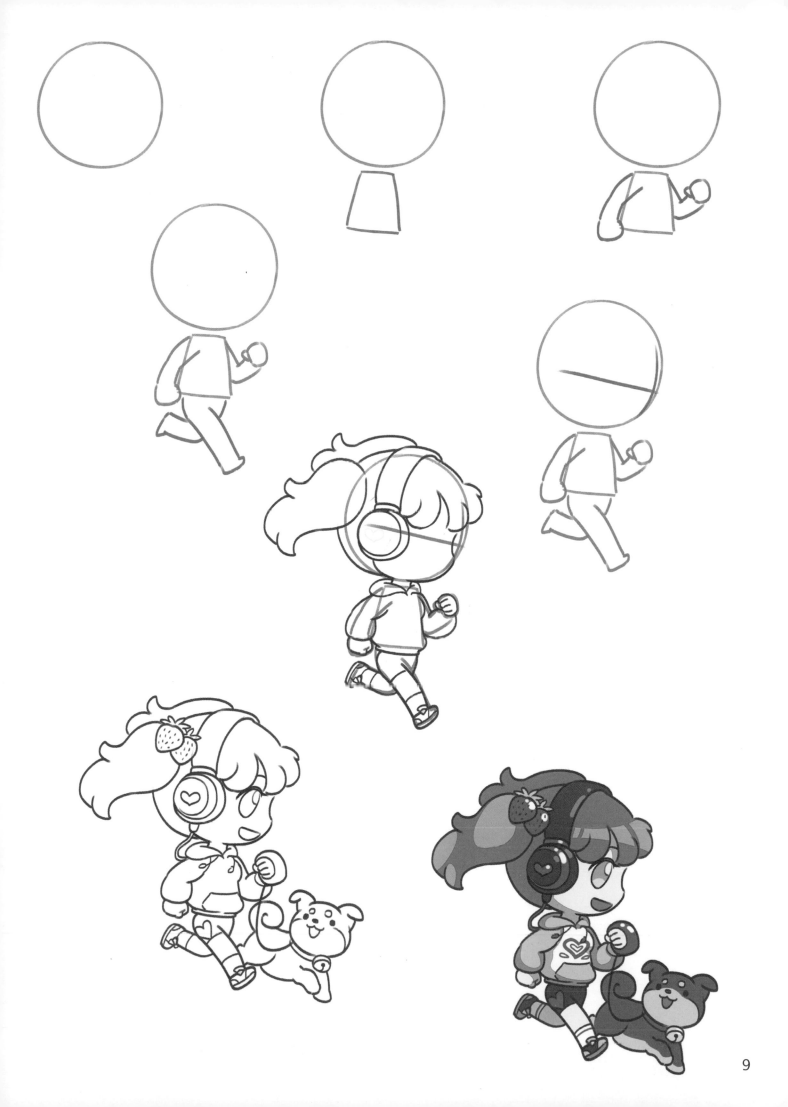

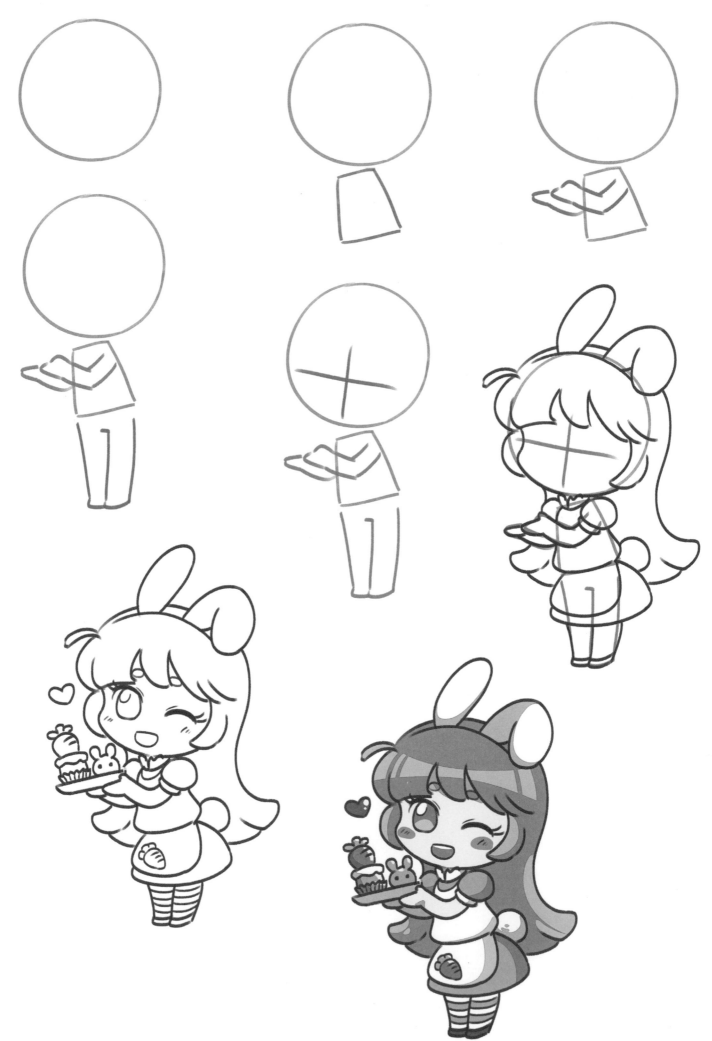

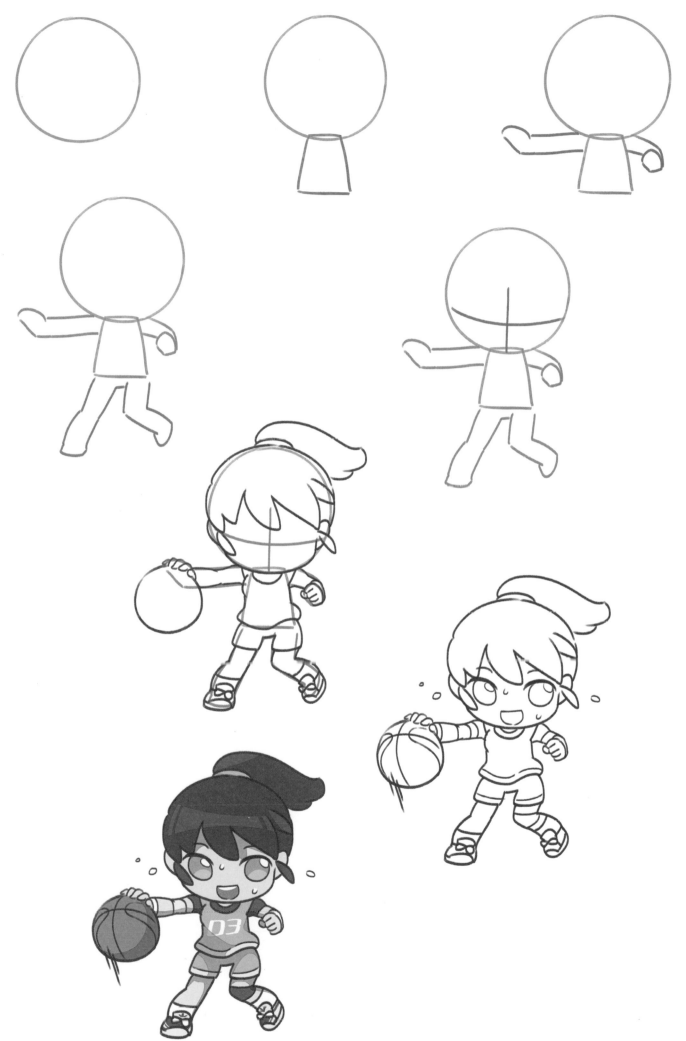

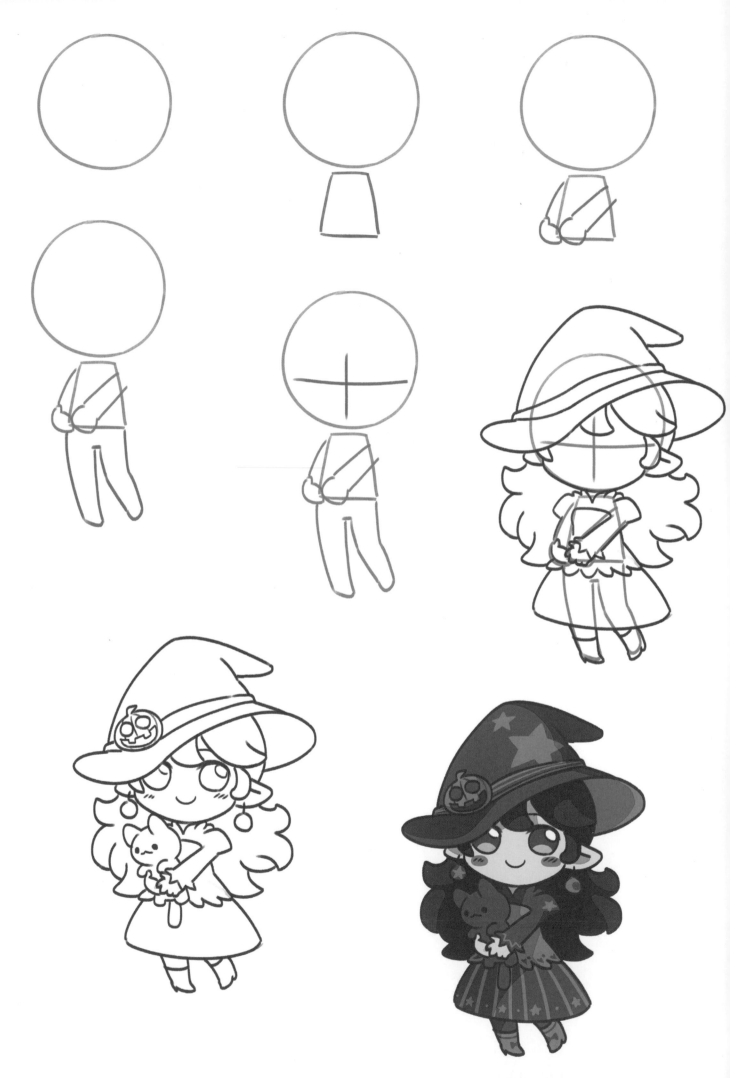

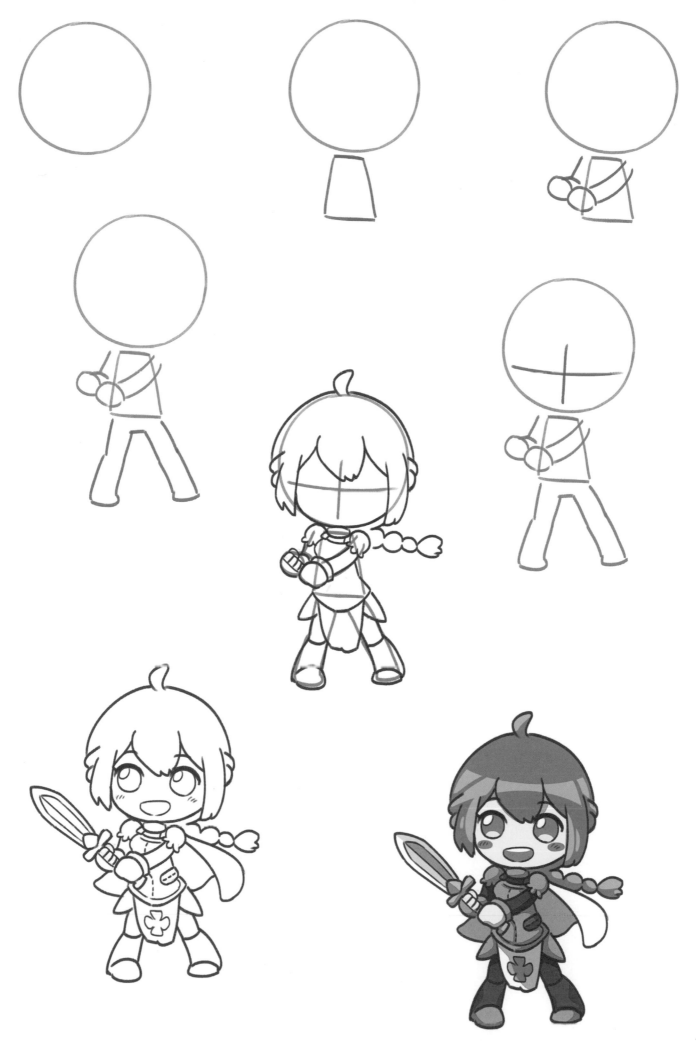

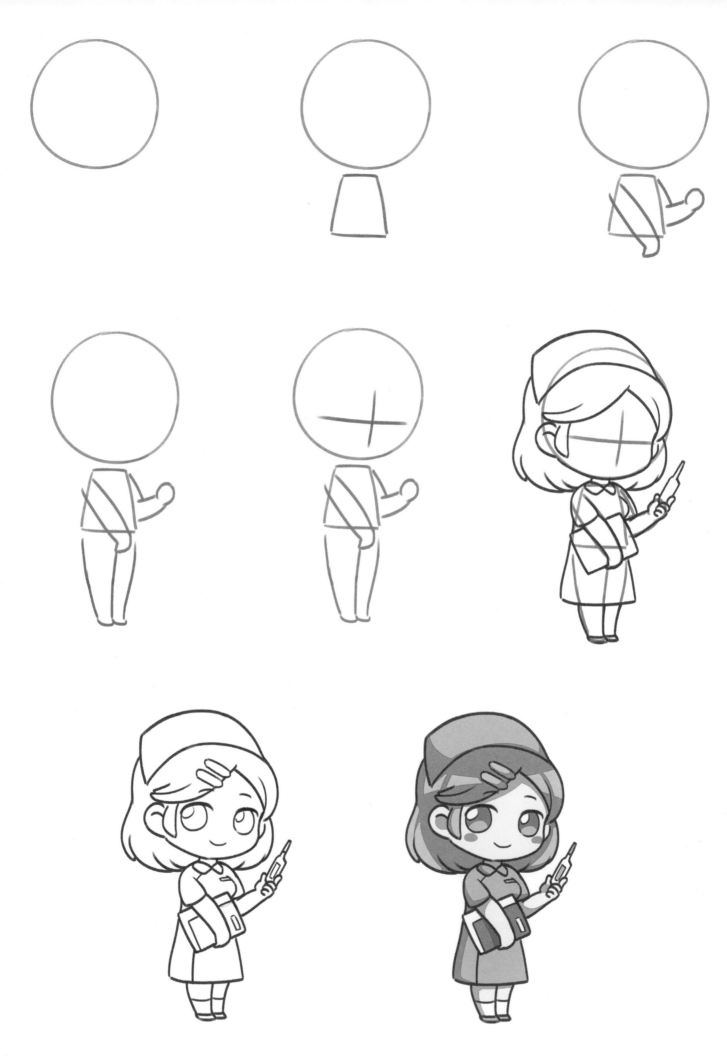

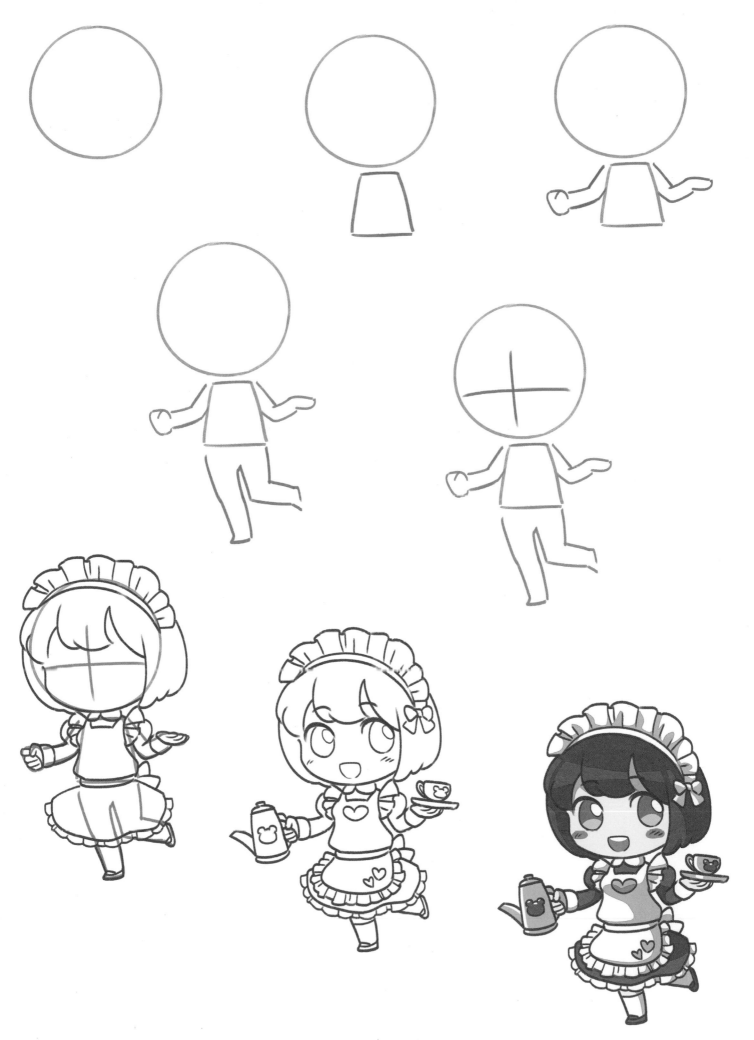

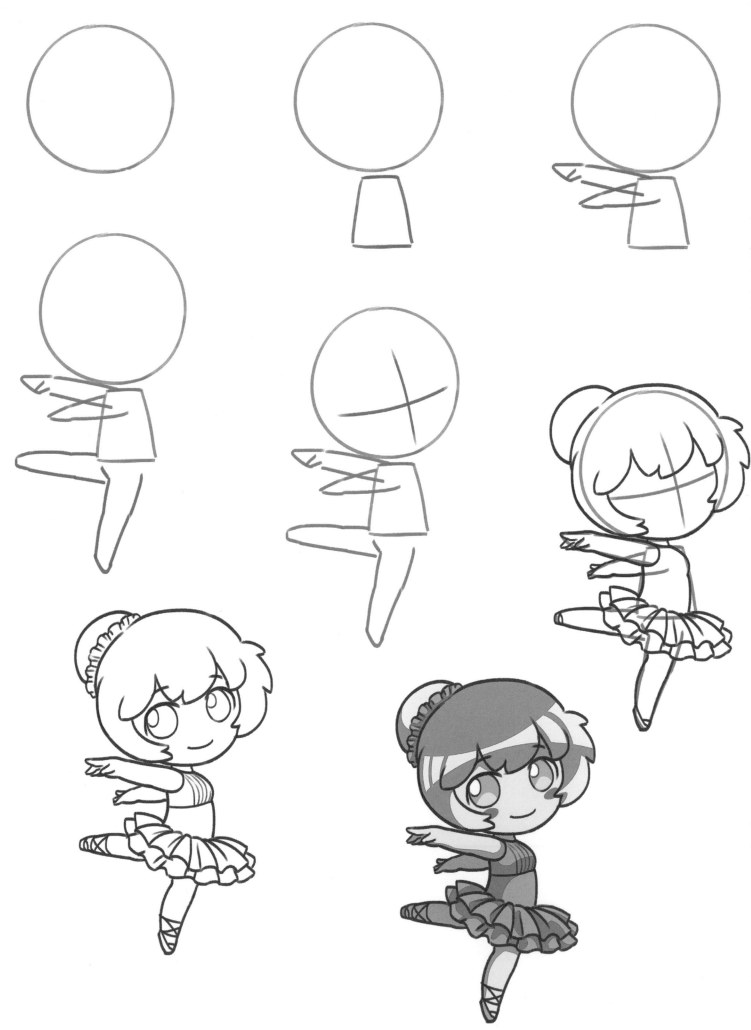

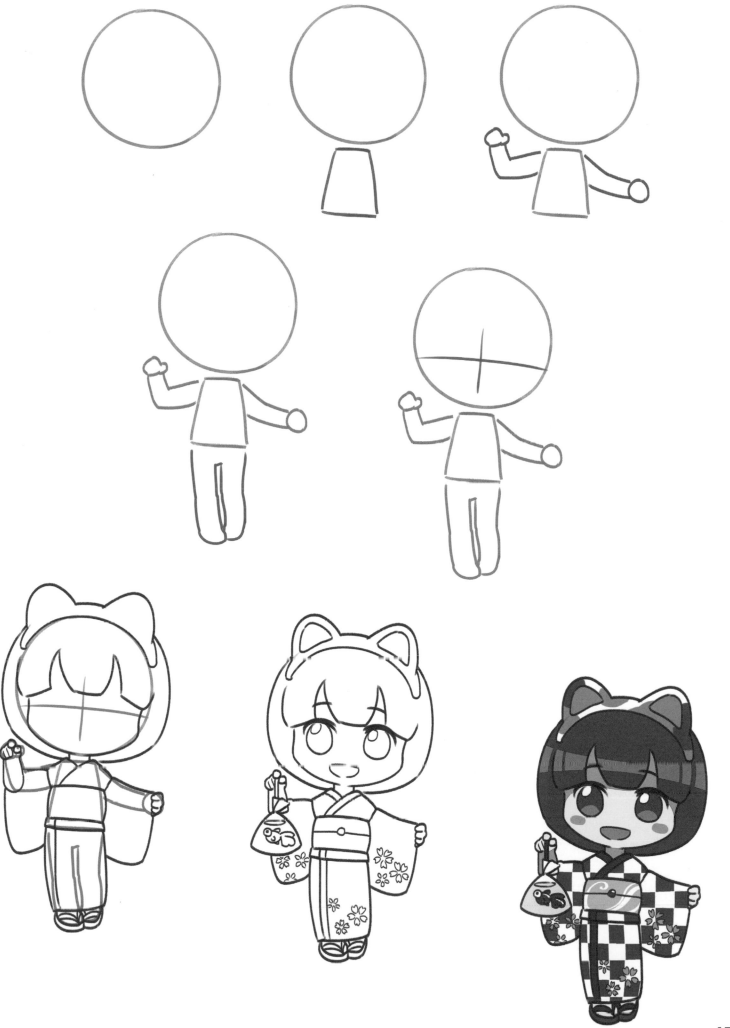

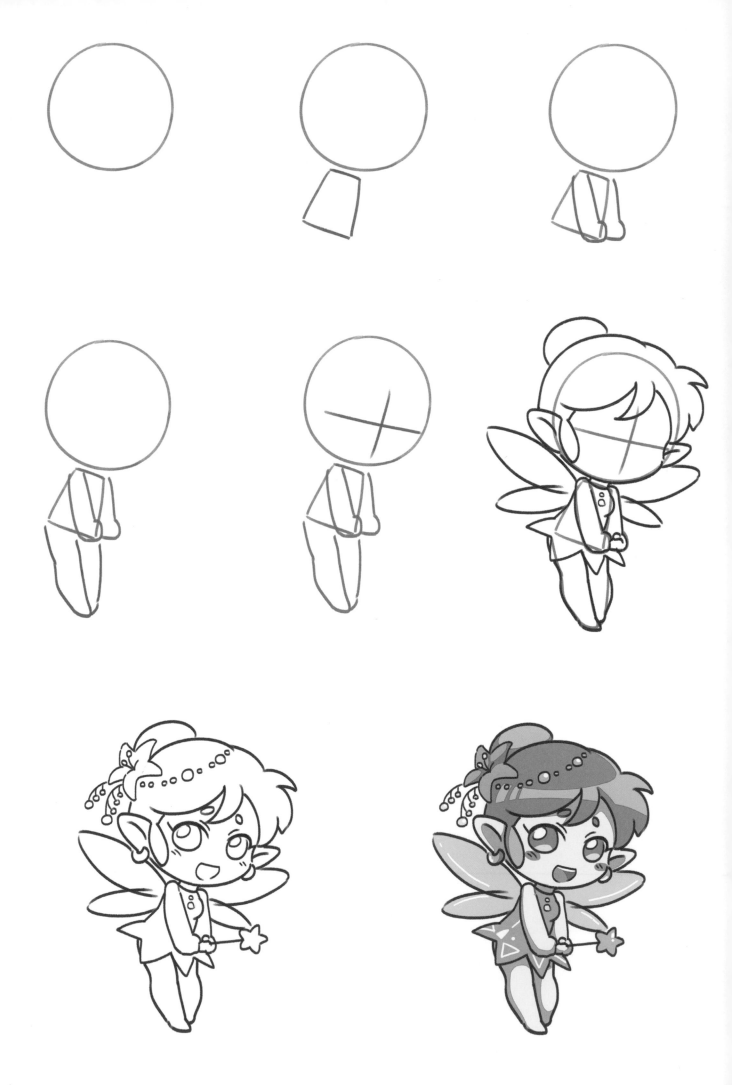

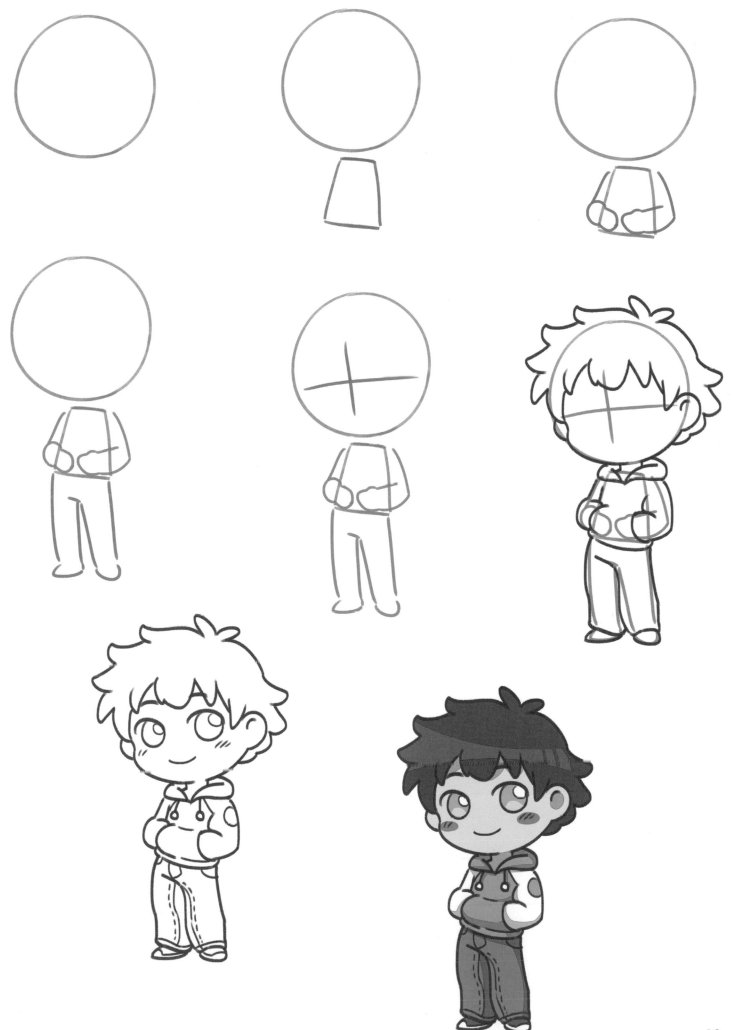

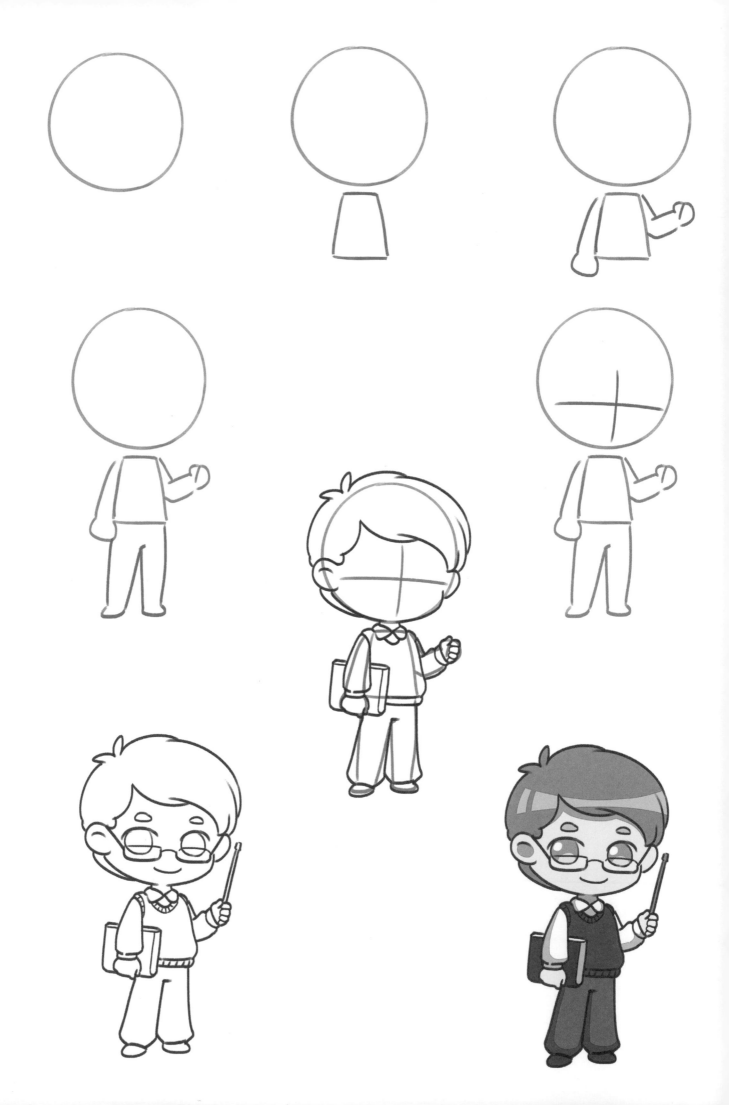

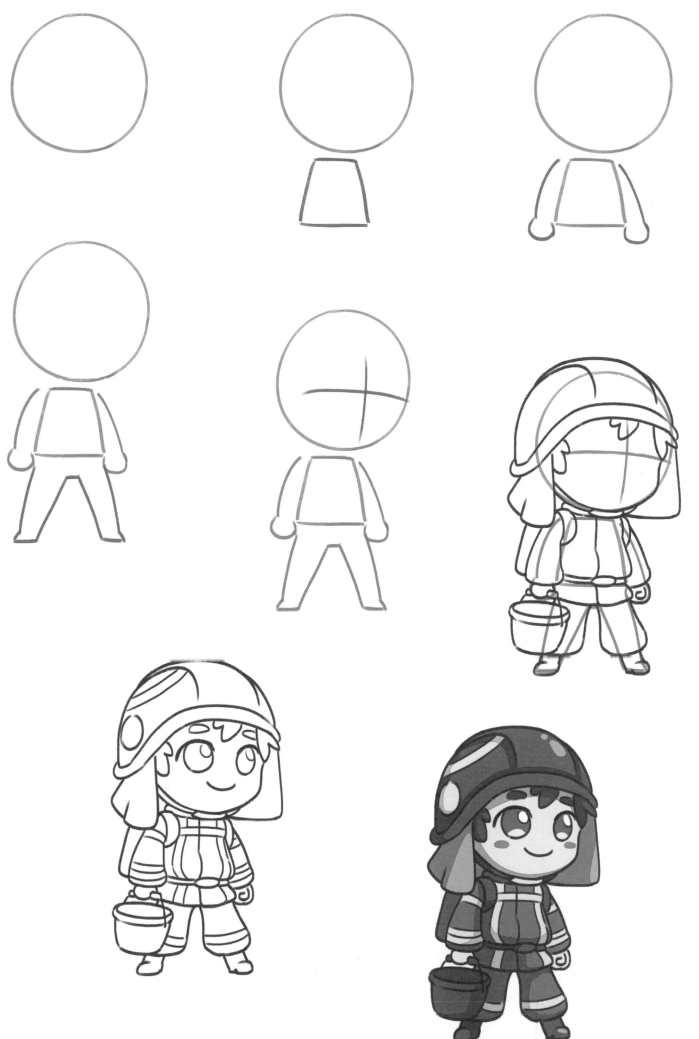

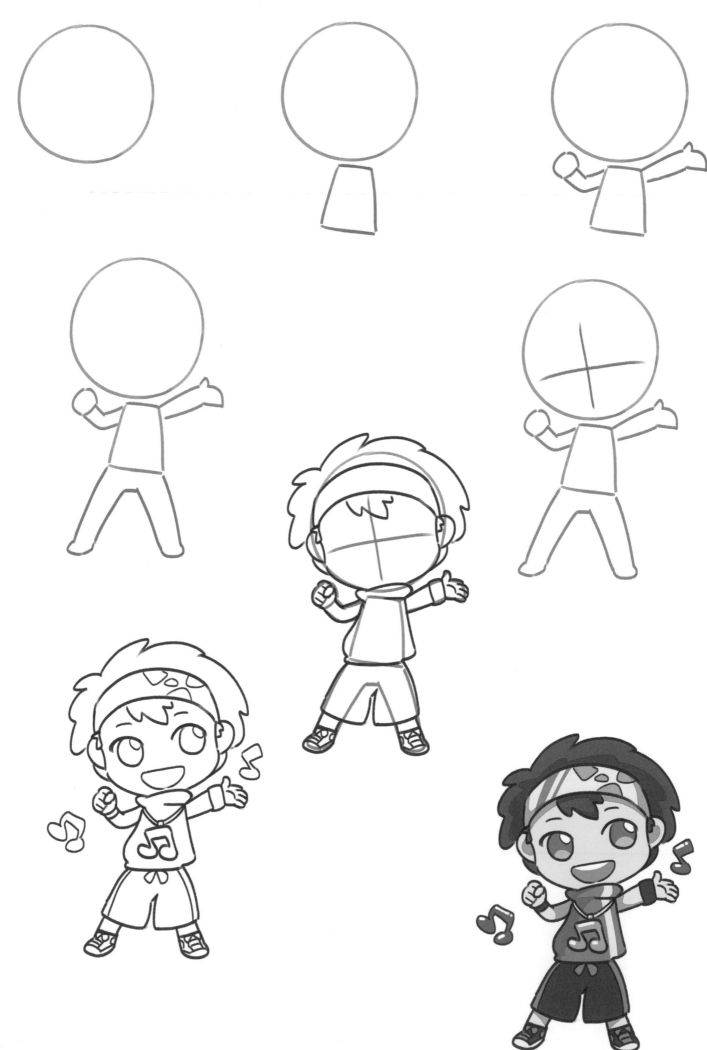

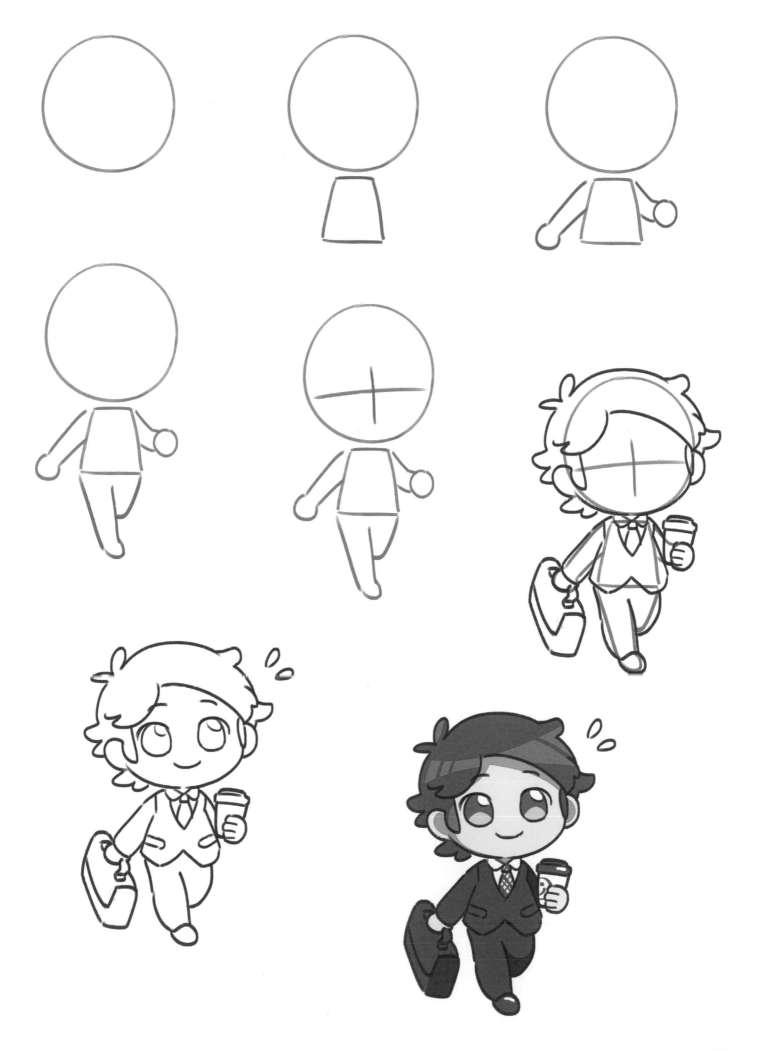

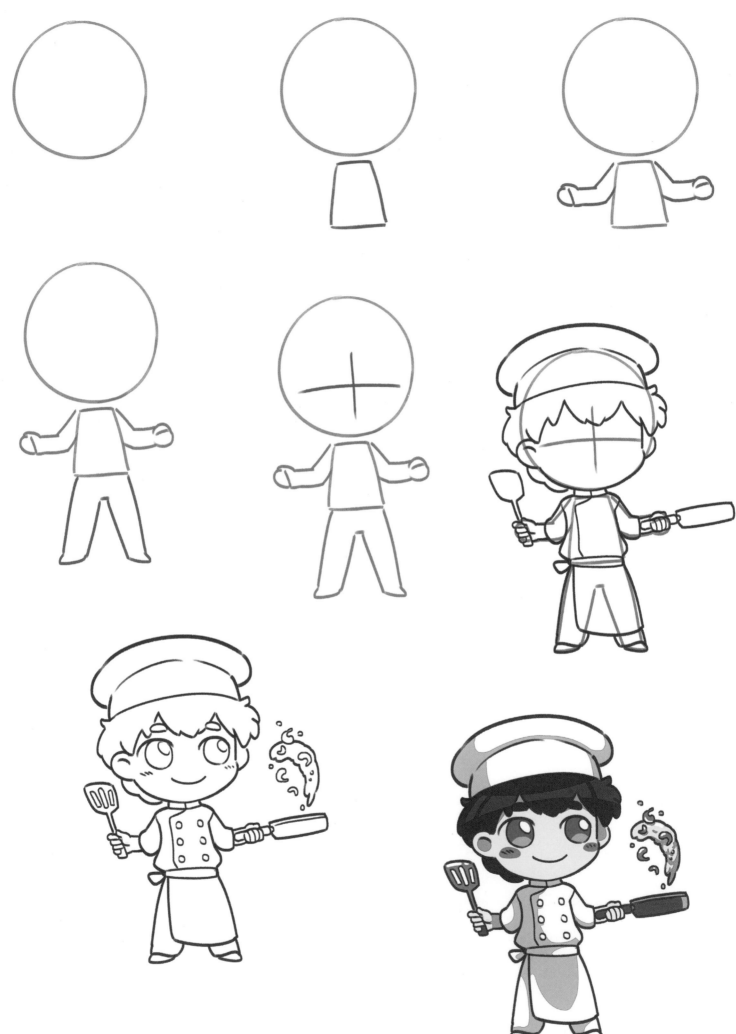

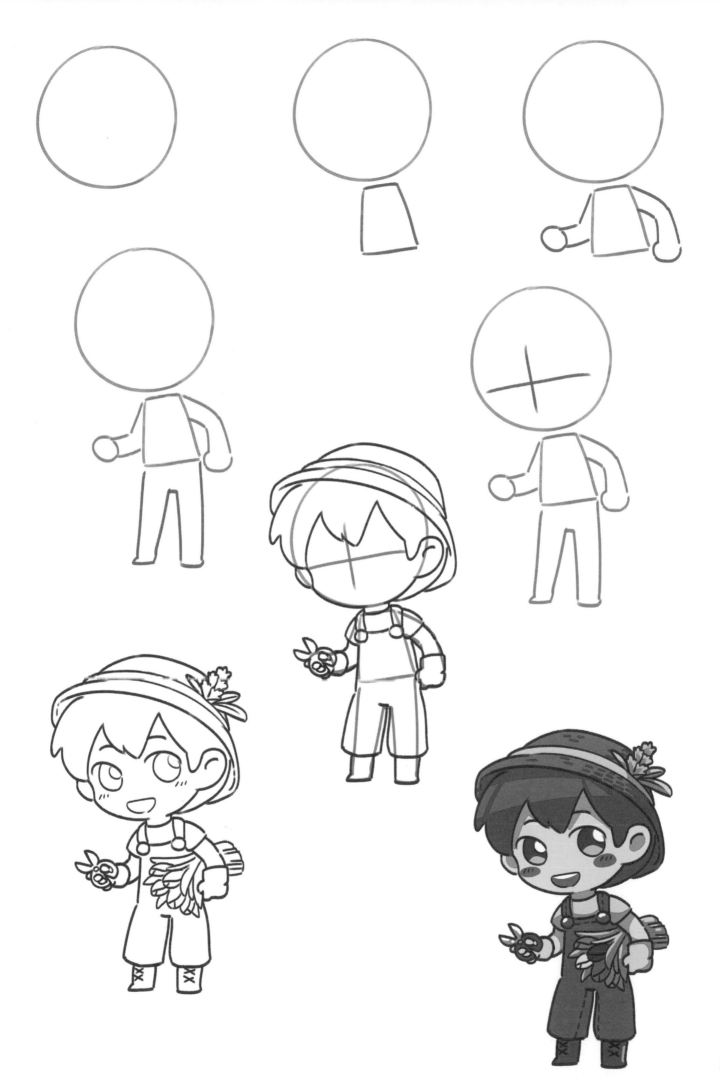

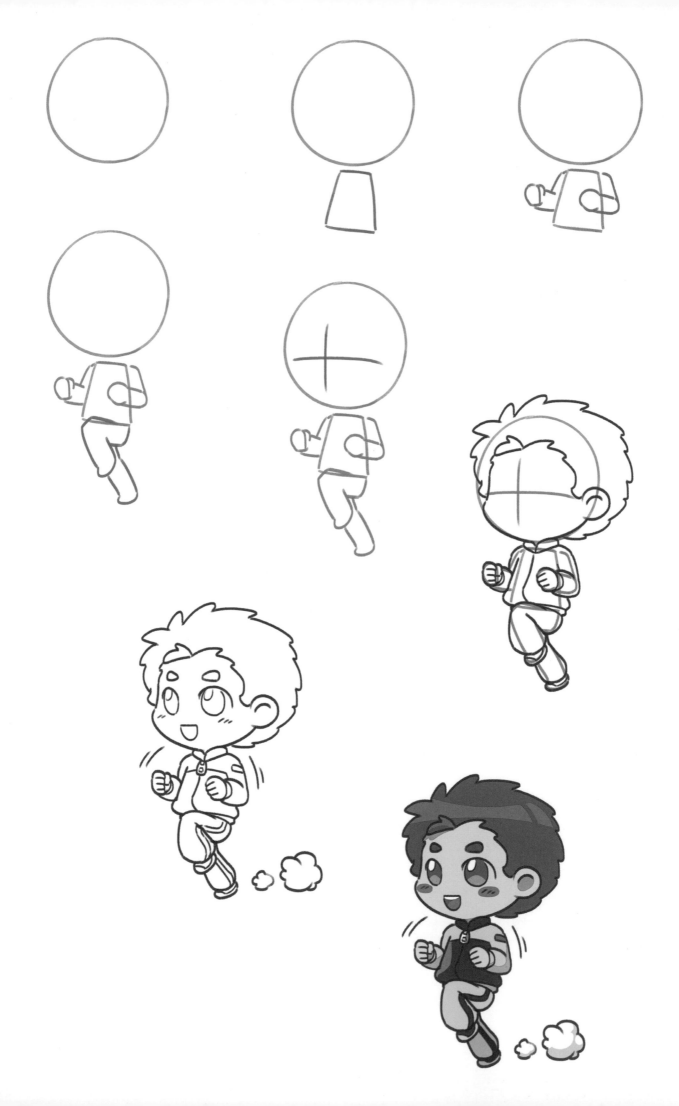

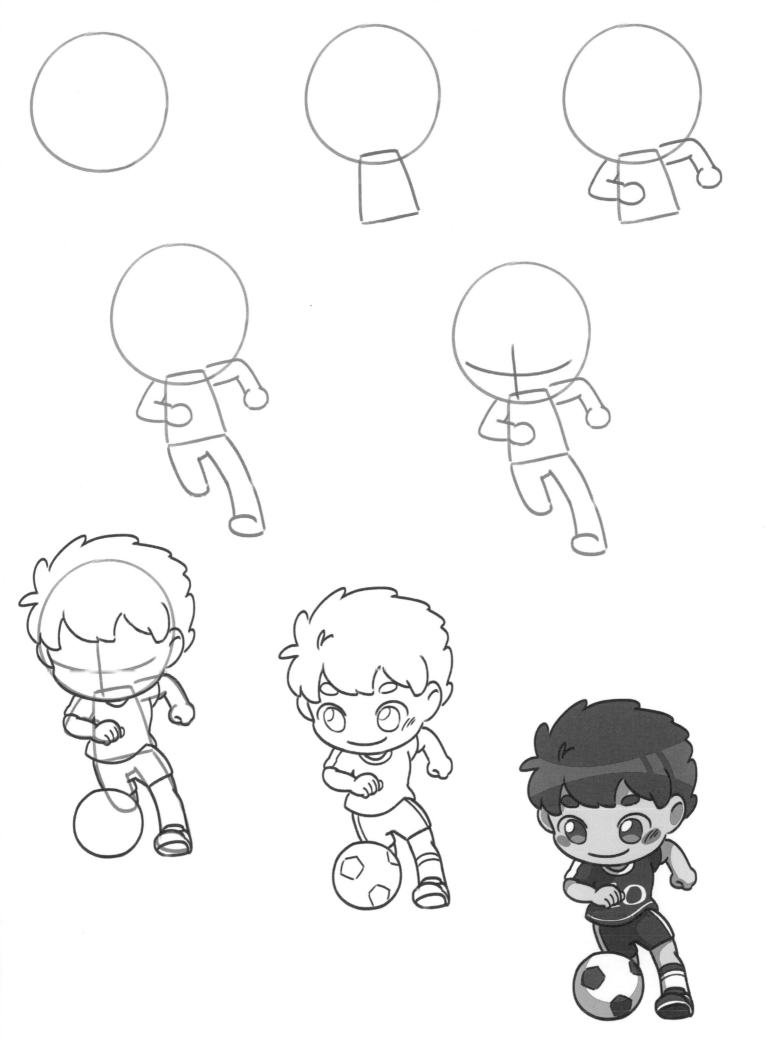

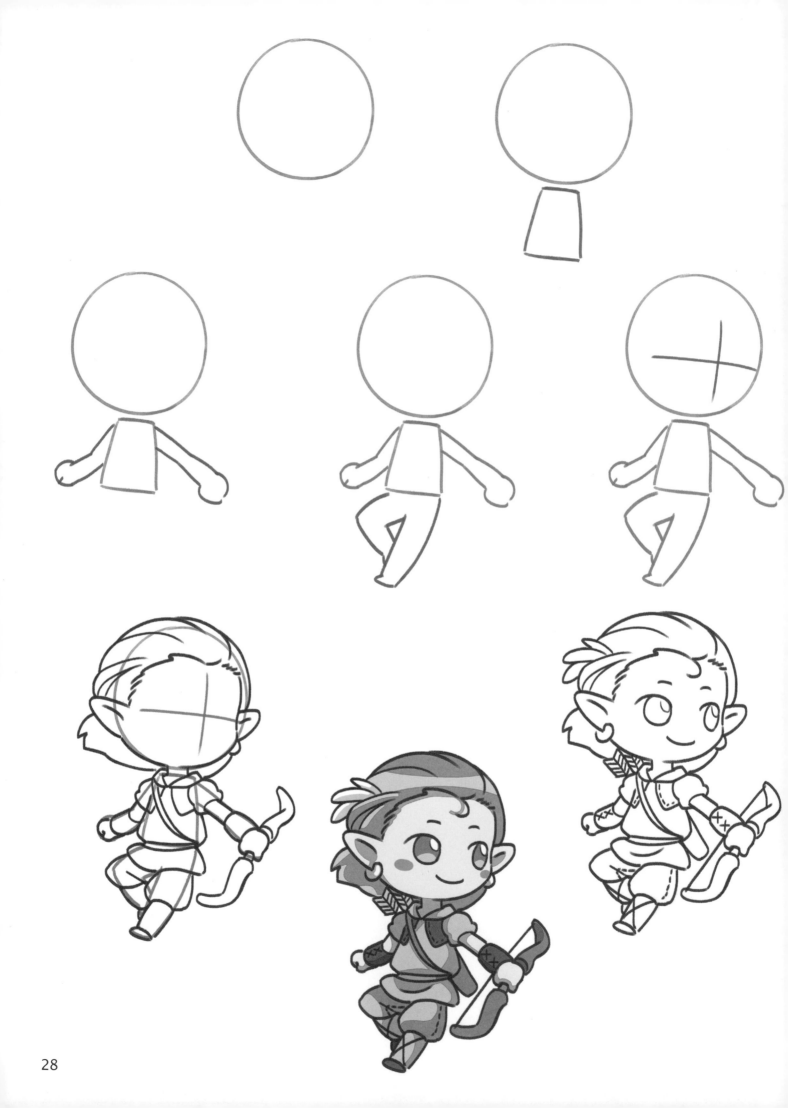

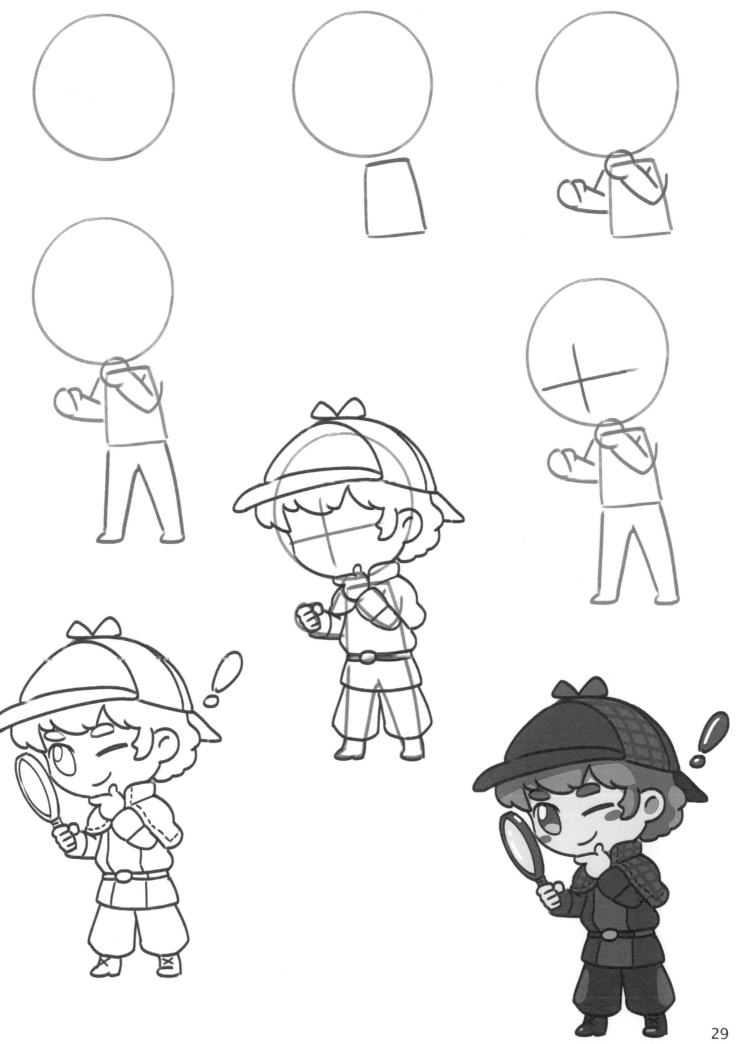

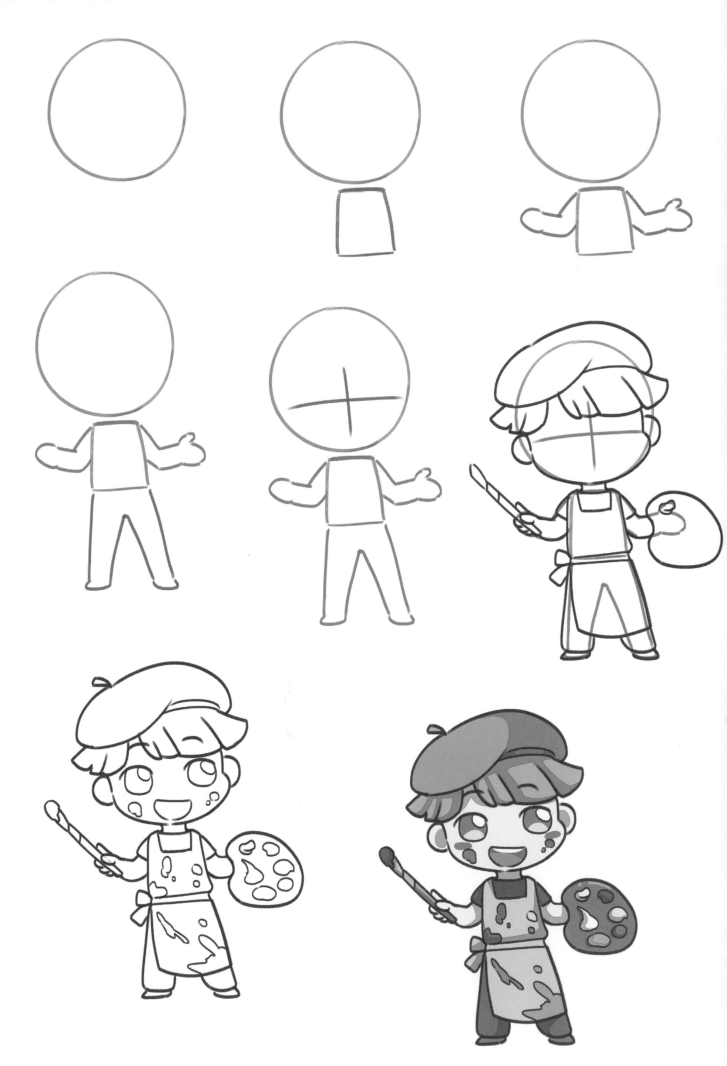

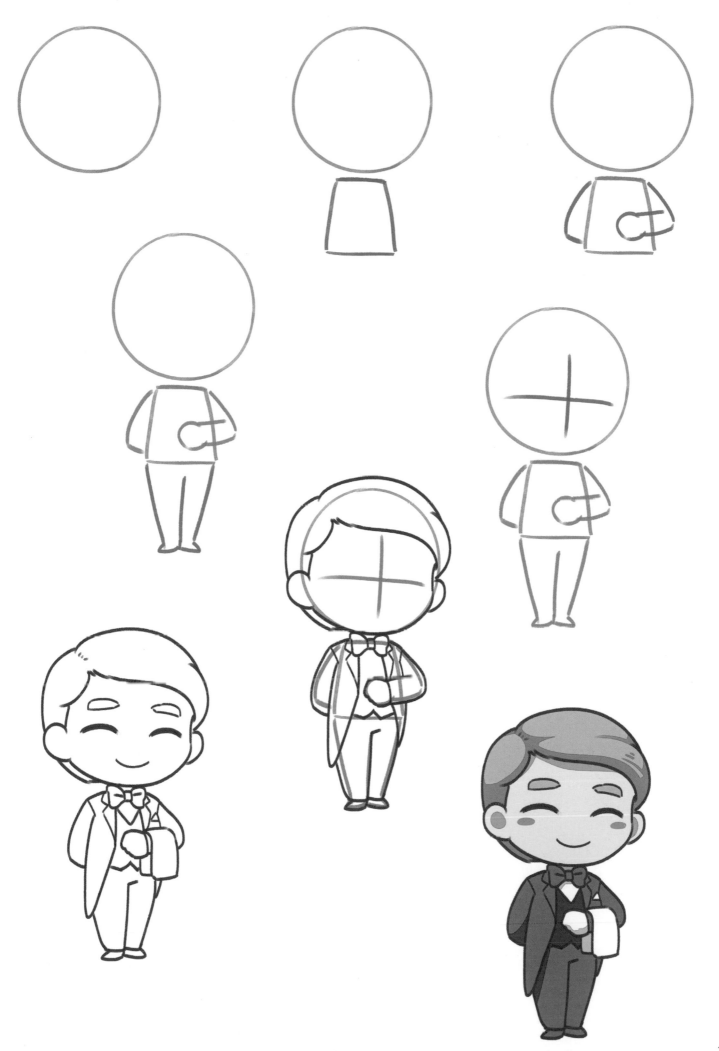

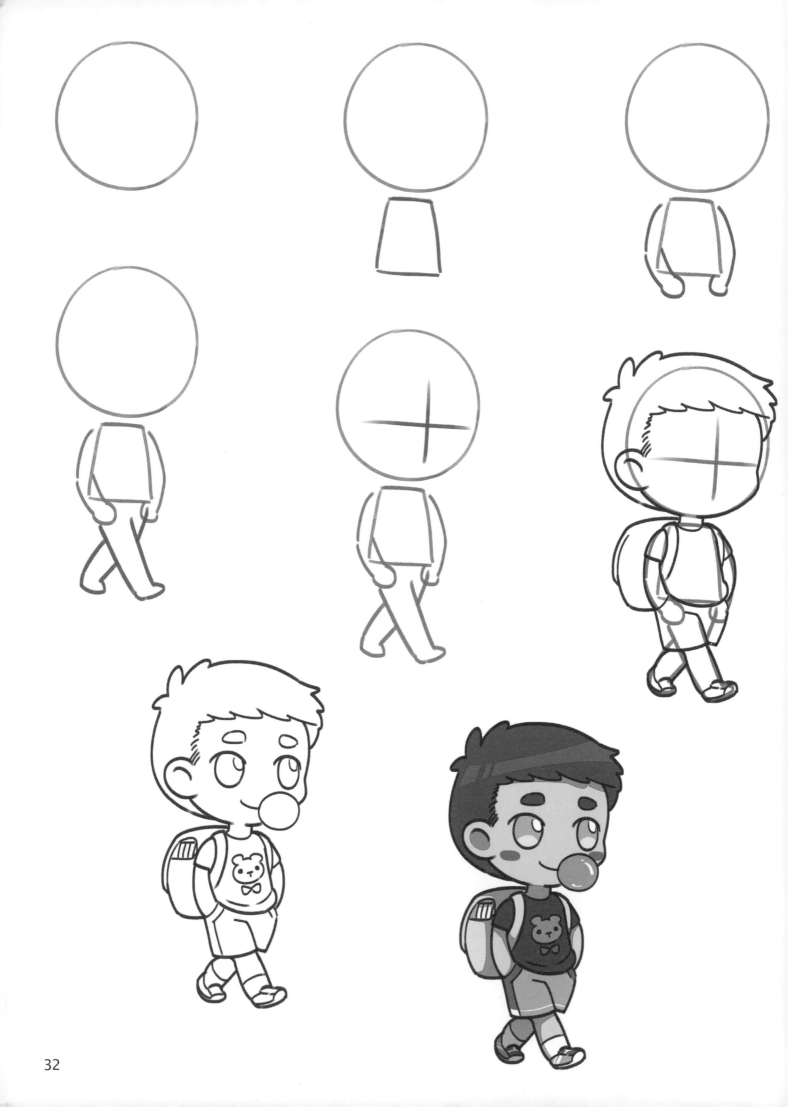